DATE DUE

APR 0 5 2007			

HIGHSMITH 45230

CONTENTS

NIAGARA FALLS

Thomas Cole

America is so many things: a country, a symbol of freedom and prosperity, a colorful patchwork quilt of people and cultures, even a state of mind. America is also a natural wonder, with mountains, prairies, deserts, forests, and bayous that stretch three thousand miles from ocean

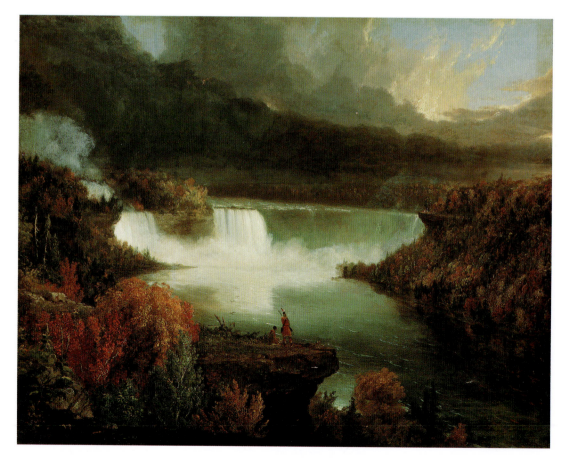

How Artists See
AMERICA
East South Midwest West

Colleen Carroll

ABBEVILLE KIDS
A DIVISION OF ABBEVILLE PUBLISHING GROUP

New York London

*"Painters understand nature and love her
and teach us to see her."*

—VINCENT VAN GOGH

———————

To my maternal grandmother, Kathleen Buckley, and to the millions
of other immigrants who came to America before and after her.

My sincerest thanks to the people who helped me complete
yet another volume in this series, especially Susan Costello,
Jacqueline Decter, Patricia Fabricant, and my agent, Colleen Mohyde.

And to my husband, Mitch Semel,
for his unending support and encouragement, times eleven.

—COLLEEN CARROLL

JACKET AND COVER FRONT: Childe Hassam, *Allies Day, May 1917,* 1917 (see also pp. 8–9).
JACKET AND COVER BACK: Frederic Remington, *A Dash for the Timber,* 1889 (see also pp. 28–29).
Romare Bearden, *New Orleans Ragging Home,* 1974 (see also pp. 14–15).
Harvey Dunn, *The Prairie Is My Garden,* 1950 (see also pp. 26–27).

EDITOR: Jacqueline Decter
DESIGNER: Patricia Fabricant
PRODUCTION MANAGER: Louise Kurtz

First library edition
10 9 8 7 6 5 4 3 2 1

Library of Congress Cataloging-in-Publication Data
Carroll, Colleen.
 America : East, South, Midwest, West / by
Colleen Carroll.— 1st ed.
 p. cm. — (How artists see)
Summary: Examines how the different sections of the United States have been depicted in works of art from different time periods and places. Includes bibliographical references and index.
 ISBN 0-7892-0772-9 (alk. paper)
 1. United States—In art—Juvenile literature. 2. Painting, American—Juvenile literature. 3. Art appreciation—Juvenile literature. [1. United States in art. 2. Painting, American. 3. Art appreciation.] I. Title.
 ND1460.U54 C37 2002
 758.173—dc21 2002074519

to ocean. And for over three hundred years America has inspired hundreds of artists to capture its beauty and grandeur. In this book, you will visit four different regions of the country. Your journey begins in the eastern United States, takes you down South, then north and across the great plains of the Midwest, and finally over the Rocky Mountains to the West. As you travel, you're sure to discover the incredible diversity of America's people and places as you see it through artists' eyes.

America as we know it today was born in the East. Here you see the region's most famous natural wonder,

Niagara Falls, in a painting made long before it became a popular tourist attraction. The mighty falls take center stage in this drama of nature's power and beauty. Find the two figures in the lower half of the picture. Compared to the majesty of the falls, these Native Americans appear quite small. Cover them up with your finger. What happens to the grandeur of the scene without people in it?

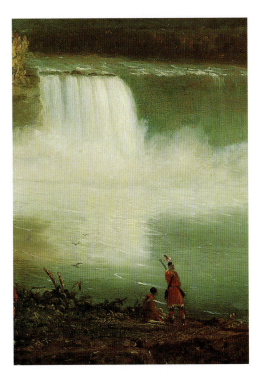

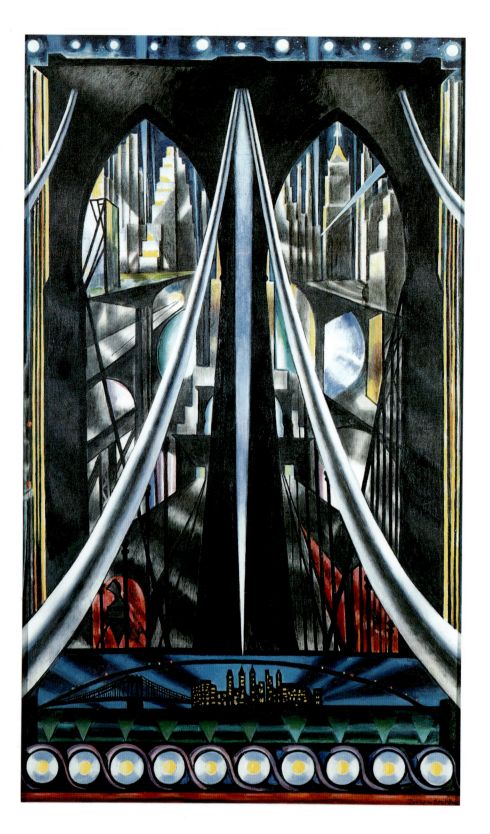

6

BROOKLYN BRIDGE: VARIATION ON AN OLD THEME

Joseph Stella

The eastern United States is home to some of the country's most beloved and recognizable landmarks. In this picture the artist gives you a rare view of a famous New York City landmark—the Brooklyn Bridge. From which part of the bridge are you looking? Like two giant, wide-open eyes, the bridge's pointed arches gaze at the cityscape in the distance. What do you see through them? The artist painted another view of the bridge at the bottom of the picture. Why do you think he chose to show it from close up and from far away?

The artist especially loved how the bridge's graceful lines and massive shapes work together to create a structure that is both strong and elegant. At first glance all these lines and shapes make the picture look busy, but it's actually very organized. Trace your finger along one of the silvery suspension cables on one side of the picture. Now trace a cable on the other side. By making the lines mirror each other, the artist balanced the two sides of the picture. What other parts of the picture are balanced in this way?

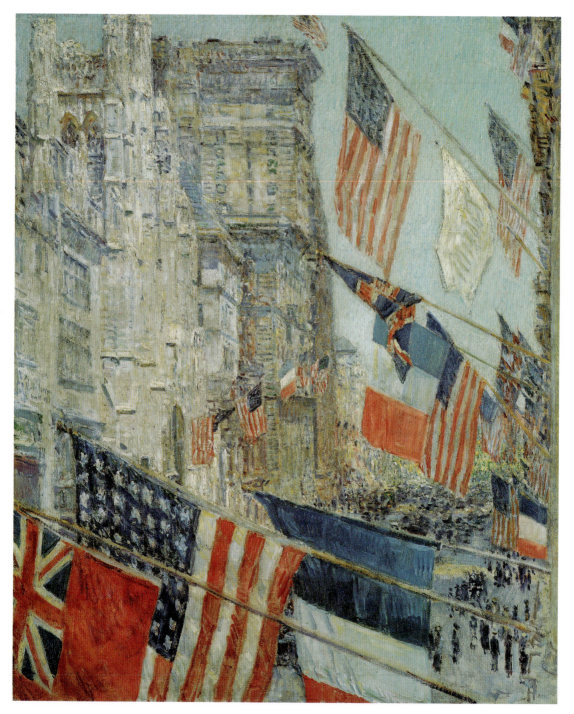

8

ALLIES DAY, MAY 1917

Childe Hassam

There's nothing that says *America* more than the American flag. Here you see a New York City street all decked out in red, white, and blue during World War I, as the flags of the United States and its allies blow in the wind above the crowds in a show of patriotic spirit. At the bottom of the picture, you see the flags of Great Britain, the United States, and France. These same flags appear over and over again, bringing your eye farther down the street. The farther into the distance you look, the smaller the flags appear. Some of the flags are very tiny. Where are they?

Although you can see things that are familiar to you, such as flags and buildings, the way the artist painted them is not as they really are. By applying the paint thickly, with many loose brush strokes, he makes everything in the picture seem slightly out of focus, as if you had only a moment to glance at the scene before turning away. If this same moment were captured with a camera, it would have a very different feeling. How would a photograph of this scene be different from the painting?

BREEZING UP (A FAIR WIND)

Winslow Homer

In a country bordered by the world's two greatest oceans, it's no surprise that American artists have turned to the sea for inspiration. The artist who made this picture was fascinated by the sea and painted many pictures of people at work and play on the ocean. On this breezy day, you see four boys out for a sail in a boat named after a New England fishing village. The boys in the stern operate the rudder and sails, while the others kick back and enjoy the ride. If you were one of these kids, what would you rather be doing? Why?

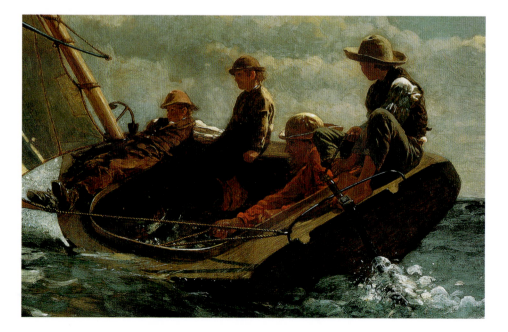

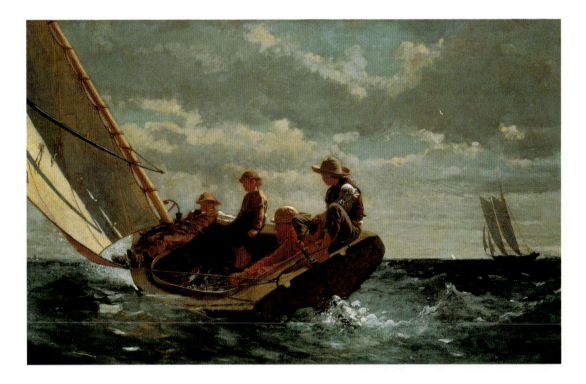

Although these children are out on the sea by themselves, there is no sense of danger. Instead, the picture has a feeling of calm pleasure. The golden light falls gently on the boys' backs, and the frisky waves hold no threat. What other things do you see in the picture that let you know the boys are safe? What words would you use to describe the mood of this picture?

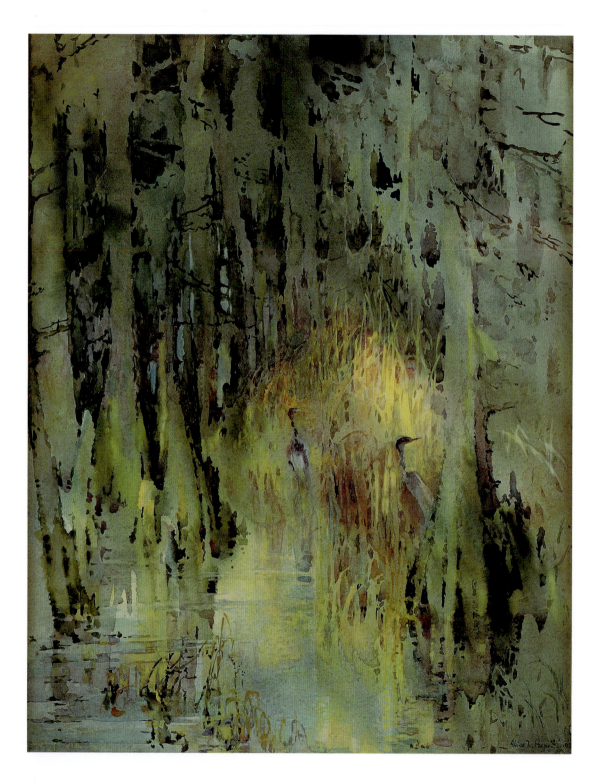

12

BAYOU SCENE

Alice Ravenel Huger Smith

Welcome to the land of Dixie, also known as the American South. Some of the most unique and wonderful areas of the South are the bayous, swampy places teeming with wildlife and natural beauty. In this picture, the artist used watercolor paints to capture the lush lowlands of South Carolina. The colors blend and overlap. How does this use of color help you experience the watery, mysterious quality of the bayou? The dense vegetation conceals all sorts of wildlife. Look closely at the scene. What creatures do you see?

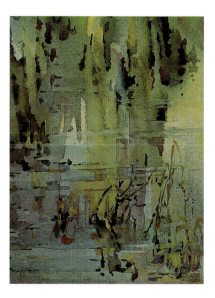

The artist who made this picture grew up in this part of the country and wanted to share the wonder of this place. Close your eyes and imagine yourself floating on a raft through this remarkable setting. What sounds do you hear? Is the air hot and sticky or cool and dry? What does being here feel like to you?

NEW ORLEANS RAGGING HOME

by Romare Bearden

The place: New Orleans. The music: jazz! In this picture, a marching band cuts a festive path through a city street as people gather on a balcony to enjoy the show. Two players on slide trombone lead the way. What other musical instruments do you see? The vivid rainbow of colors that the artist used throughout the picture expresses the gaiety of the event. How many different colors can you find? Close your eyes and imagine yourself watching the parade from the balcony. What does the music sound like to you?

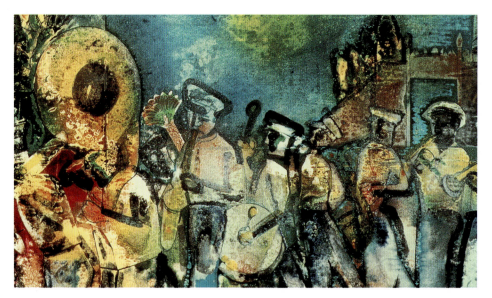

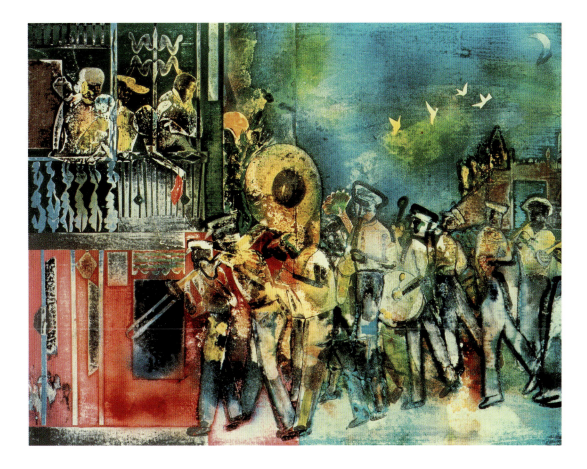

Most of the pictures in this book were made with one type of material, such as oil paint or watercolors. In this picture, the artist used a variety of materials, creating what is known as a *collage*. In addition to ink and paint, the artist used paper and old photographs, which he cut out and pasted onto the board. Where are they? He also outlined some of the people with ink. Trace your finger around these figures. Why do you think the artist chose to use this mixture of materials?

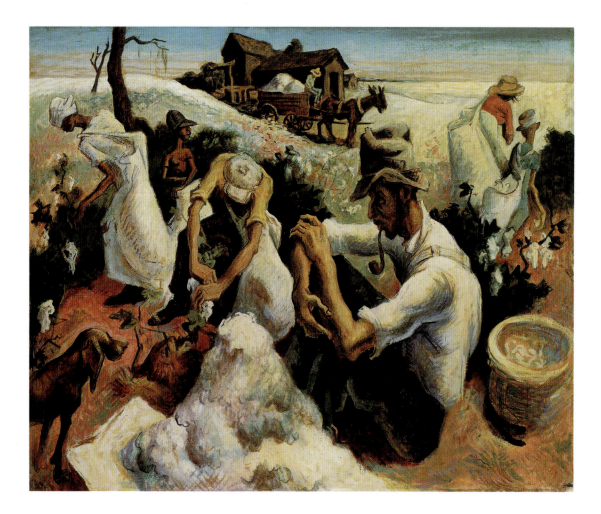

THE COTTON PICKERS

Thomas Hart Benton

The American South is a fertile land of plenty. Many things grow here, but cotton is king. In this picture, a group of cotton pickers toil in the hot sun. As far as the eye can see, all the way to the horizon, fields of white wait to be harvested and turned into cloth. Picking cotton may seem easy, but it is back-breaking work. Imagine yourself hunched over in this field from sunup to sundown like some of the people you see here. How would your hands and muscles feel at the end of the day?

In the previous picture, the artist used color to express a joyous mood of fun and celebration. The colors in this picture convey a very different feeling. Even though the sun shines down, there is a darkness here that gives the scene a somber, heavy feeling. Besides white, what colors do you see? Why do you think the artist chose to use these colors in his picture? In what other ways has the artist created a melancholy mood?

17

GEORGIA RED CLAY

Nell Choate Jones

Welcome to Georgia, land of sweet, juicy peaches and the reddest clay soil you'll see in the South. Although there are no people in the picture, the scene is anything but dull. The intense red of the earth and the vivid greens of the trees and shrubs pulsate with energy. Even the sky is a vibrant blue that seems to take on a life of its own. Why do you think the artist chose to paint this scene with such bold colors?

To help you experience the richness of this red earth, the artist applied the paint with long, thick brush strokes. Swirling movement is everywhere

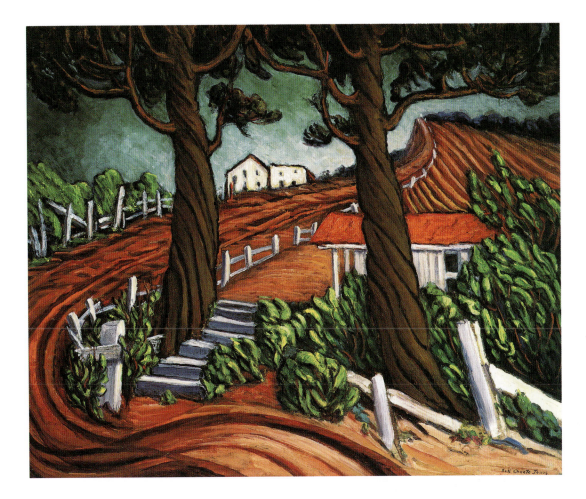

Starting at the bottom of the picture, trace your finger along the lines of the road until you reach the background. Where else do you see these thick, curving lines of paint? If you could pick up a handful of this clay in your hands, what do you think it would feel like?

FUR TRADERS DESCENDING THE MISSOURI

George Caleb Bingham

When people think of the Midwest, or middle-western region of the Untied States, they imagine acre after acre of cornfields stretching in a band of gold across a huge, flat plain. It's true that the Midwest is the farm belt of America, but it's so much more than that. This picture takes you back to a time when the region was still a young, unexplored wilderness where people went to claim their fortunes and live a life of adventure. Here you see a man and his son slowly making their way down

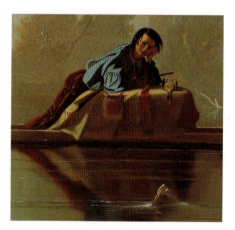

the mighty Missouri River. Both of them look directly at you. Their steady gaze invites you into the picture and into their world. The boy is probably not much older than you, but his life is very different from your own. If you were to meet him, what might you talk about?

To make the picture realistic and to capture your imagination, the artist included many details from life at that time. Everything from the ripples on the water to the

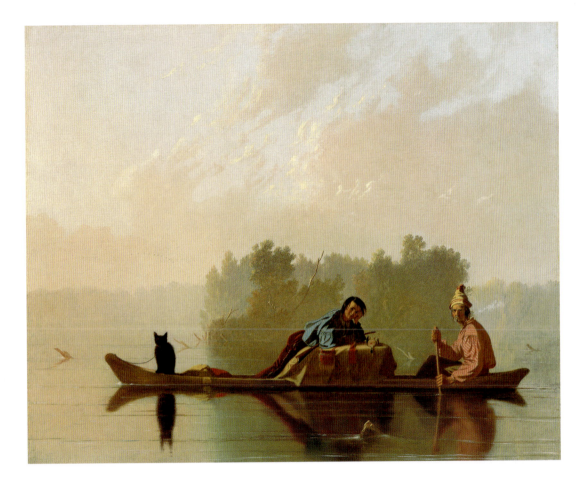

objects in the canoe help to create a
realistic view of this part of the country.
The boy lies over what appears to be
a large box covered by a blanket.
What do you think is in the box?
What other small details do you see
that make the picture feel so authentic?
What dangers might the man and his
son encounter on their journey?

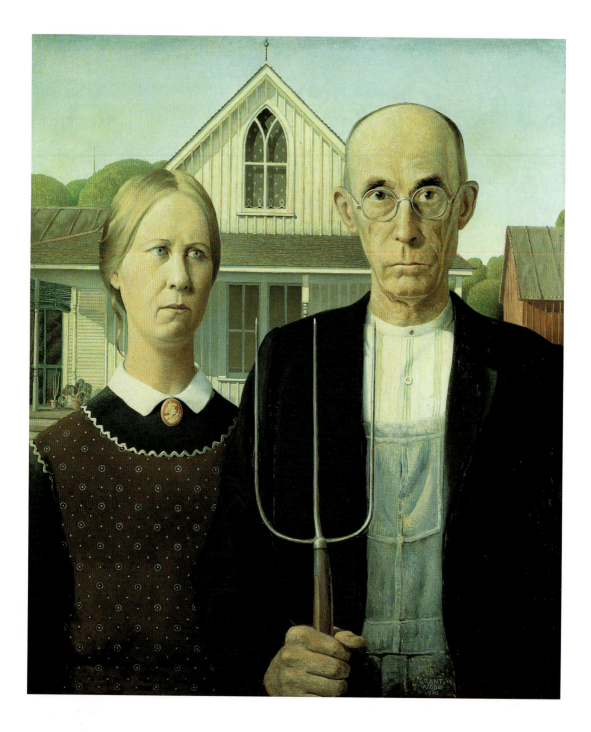

MIDWEST
AMERICAN GOTHIC
Grant Wood

You don't know these no-nonsense folks by name,
but you've probably seen them before. This picture of a
man and woman standing in front of their simple white
farmhouse is one of the most well-known images ever
painted of the American Midwest. In his plain overalls
and with his stiff-lipped expression, the farmer is a
symbol of the simple values and hard-working character
of some Midwestern people. The plainly dressed woman
looks away at something that the artist does not
let you see. What could she be looking at?
Do you think she's comfortable having
her portrait painted?

The picture's space is divided into two
parts: foreground and background.
To bring the two spaces together, the
artist repeats shapes and patterns that
lead your eye from the front of the
picture to the back, such as the fabric
of the woman's apron and the lace
curtain hanging in the house's arched
window. What other repeated shapes
and patterns can you find?

THE PRAIRIE IS MY GARDEN

Harvey T. Dunn

The next two pictures show two starkly different visions of the Midwestern plains. In this one, a young mother and her two children pick wildflowers on the prairie not far from their house and barn. While one of her daughters gathers blossoms, the mother stares off at something, or someone, in the distance. Like a warrior-goddess, she

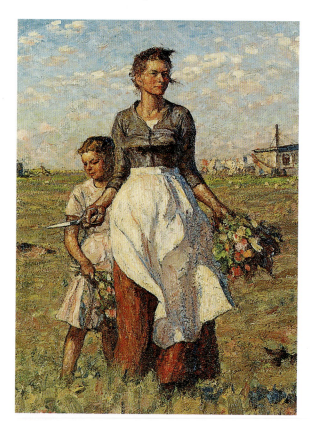

stands ready to protect her land and family. How has the artist made her appear so strong and determined? What do you think she sees out on the plains? Do you think she and her girls are in danger?

24

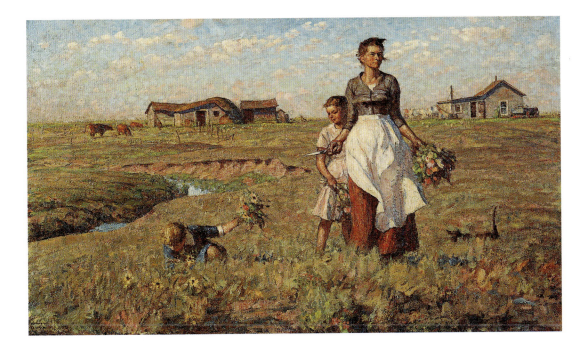

The artist used warm earth tones such as red, yellow, orange, and brown to lighten the tension of the scene and express the harsh beauty of the open prairie on a summer day. Orange sunlight falls over the land, bathing the picture in warmth. Where else does the artist show you this golden light?
What time of day do you think it is?

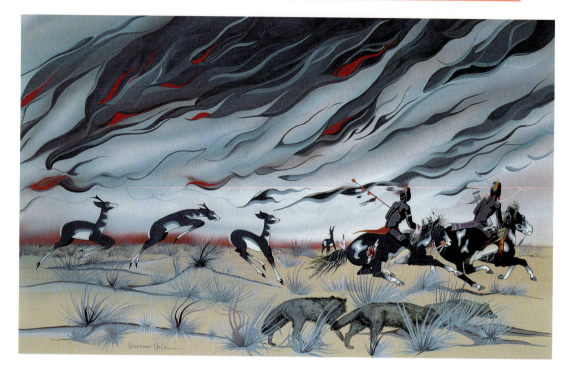

PRAIRIE FIRE

Francis Blackbear Bosin

As you have just seen, the prairies of the Midwest are vast and beautiful, but they are also places where the forces of nature, such as tornadoes, drought, and wildfires, can wreak havoc. In this picture, a prairie fire rages out of control, and Native Americans on horseback, deer, and coyotes race to escape the inferno. One deer has stopped to watch the approaching fire. Do you think it will make it back to its herd before the fire consumes the land?

With the exception of that one deer, everything in this picture is moving. Like the fire itself, the entire prairie is alive with motion and energy. To capture the force of the smoke and flames raging across the sky, the artist uses strong, curving lines. Quickly trace your fingers across the lines to experience the fire's power and speed. What seems to be moving faster, the fire or the animals and people trying to outrun it? Do you think they have enough time to find shelter?

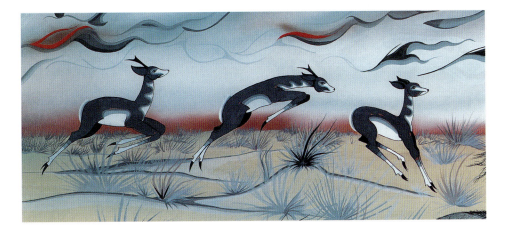

A DASH FOR THE TIMBER

Frederic Remington

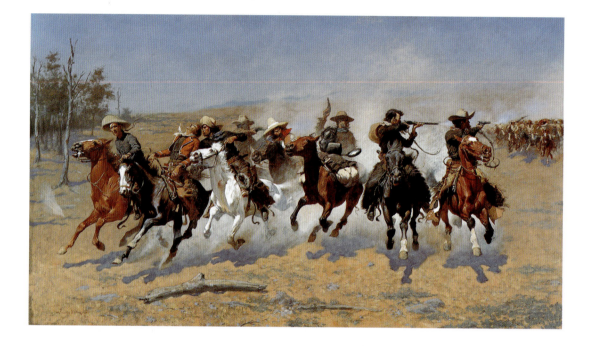

Picture in your mind enormous canyons, red rock cliffs, parched deserts, and rugged mountains, and you could only be in one place: the American West. And the West just couldn't be called wild without those classic rivals of the range—cowboys and Indians. In this picture, a large band of Indians pursue eight seriously outnumbered cowboys. The western frontier is harsh and barren,

yet the scene is full of life, energy, and action. The artist puts you right in front of the galloping horses to help you experience the thrill and terror of the cowboys charging toward you at breakneck speed. In what other ways does the artist show movement?

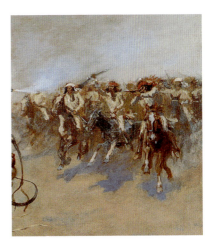

The panicked horses flare their nostrils as their riders struggle to fire their weapons and stay mounted at the same time. What other details do you see that give this scene a feeling of excitement and

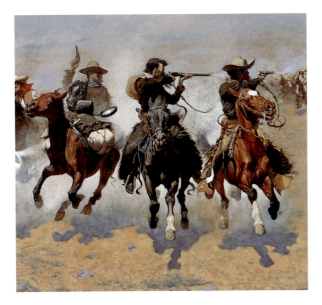

suspense? Imagine yourself as one of the people in the picture. What sounds do you hear? Do you think the cowboys will make it to the woods? Which group would you rather be riding with?

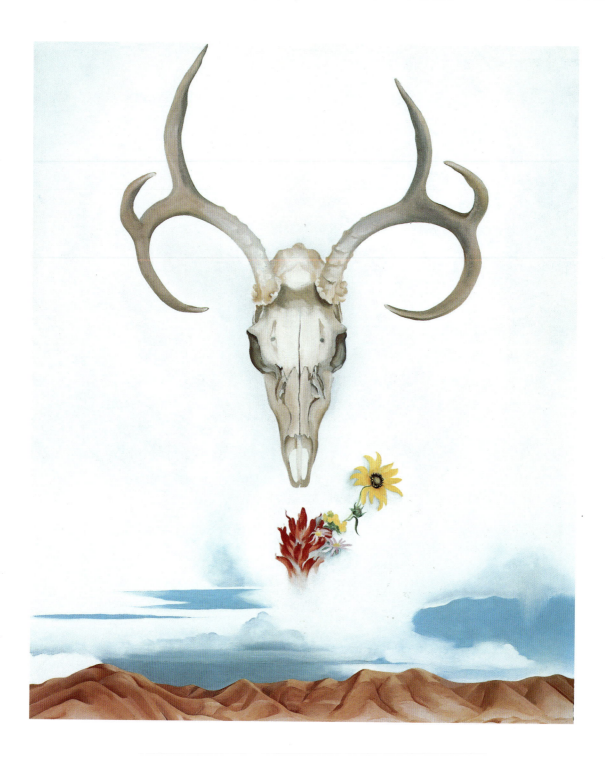

SUMMER DAYS

Georgia O'Keeffe

An animal skull floating in the clouds over the desert's red hills is a vision of the American West like no other. This artist collected bones and other objects to help her describe the "wideness and wonder of the world." To help *you* feel the openness of the Southwest, the artist placed the skull and desert wildflowers amid "miles" of clouds and sky. Just above the hills the white clouds seems to shift and move, giving you a glimpse of blue sky. How do the openings in the clouds create a feeling of distance?

In this picture the artist is showing you that the desert is a harsh place, but it's also a place of unexpected beauty and mystery. To her, the skull is a symbol of the desert as well as an object made of beautiful lines and shapes. Trace your finger along the antlers to experience their graceful lines. How else does the artist depict the mysterious beauty of the desert?

CLIFFS OF THE UPPER COLORADO RIVER, WYOMING TERRITORY

Thomas Moran

As you've already seen, the American West can be a rugged, dangerous, wild, harsh, and beautiful place. While the Midwest has those famous "amber waves of grain," the West is home to the awesome red rock cliffs

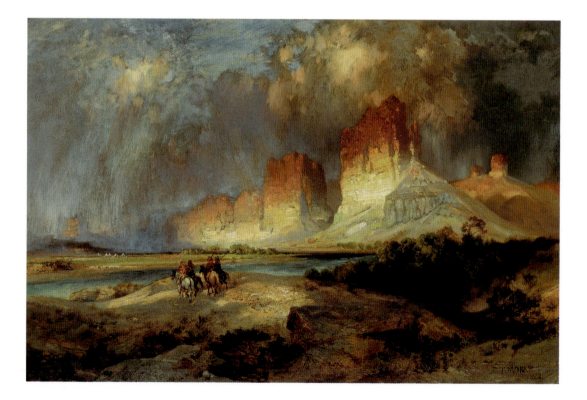

that rise like giant sculptures above the plains. In this vista set along the Colorado River, the clouds explode with color like fireworks. What colors do you see? The artist made this picture with colors that are even more intense than they usually appear in nature. Why do you think he would alter the color of the landscape?

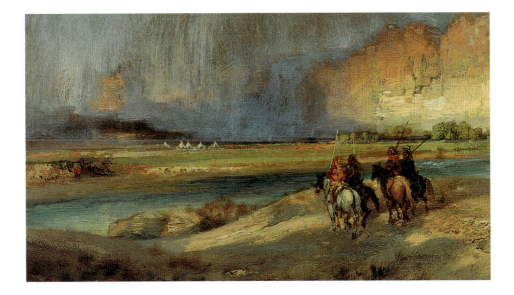

A small band of Native Americans move on horseback toward an encampment in the distance. Can you find it? Do you think these braves come in peace? If you were writing a story about this picture, what would they do next?

MULHOLLAND DRIVE: A VIEW FROM THE STUDIO

David Hockney

Jump in the car, pop the top, and take a cruise along this famous road in Los Angeles, California. Drive up the hill along the gray, yellow-lined road that begins at the bottom of the picture and then winds across the top of the canyon. How does the scenery change as you move along the road?

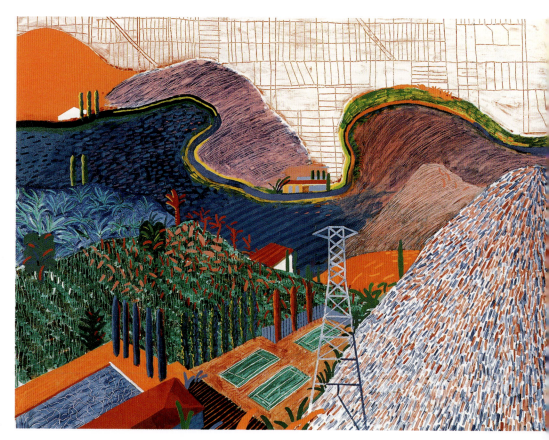

In the artist's eyes, the canyon becomes a flat, wide panorama of patterns that bump up against each other in a riot of color. How many different patterns can you find? Some of them are easier to identify than others. Which ones do you recognize? Even the lifeless grid of the streets and boulevards on the other side of the canyon forms a pattern of horizontal and vertical lines. Which side of Mulholland Drive do you think the artist prefers?

Now that you've seen some of the ways artists see America, try making a picture of your own part of the country.

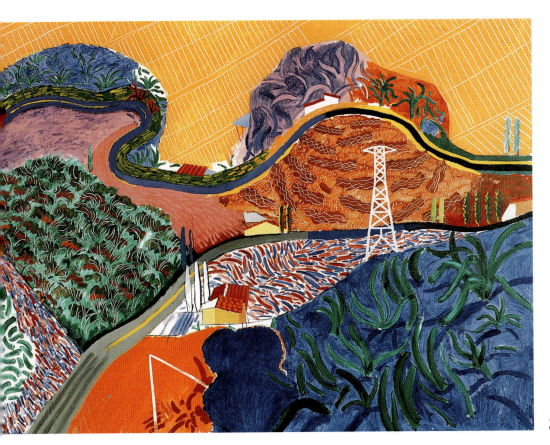

NOTE TO PARENTS
AND TEACHERS

As an elementary school teacher I had the opportunity to show my students many examples of great art. I was always amazed by their enthusiastic responses to the colors, shapes, subjects, and fascinating stories of the artists' lives. It wasn't uncommon for us to spend an entire class period looking at and talking about just one work of art. By asking challenging questions, I prompted the children to examine and think very carefully about the art, and then quite naturally they would begin to ask all sorts of interesting questions of their own. These experiences inspired me to write this book and the other volumes in the *How Artists See* series.

How Artists See is designed to teach children about the world by looking at art, and about art by looking at the world through the eyes of great artists. The books encourage children to look critically, answer—and ask— thought-provoking questions, and form an appreciation and understanding of an artist's vision. Each book is devoted to a single subject so that children can see how different artists have approached and treated the same theme, and begin to understand the importance of individual style.

Because I believe that children learn most successfully in an atmosphere of exploration and discovery, I've included questions that encourage them to formulate ideas and responses for

themselves. And because people's reactions to art are based on their own personal aesthetic, most of the questions are open-ended and have more than one answer. If you're reading aloud to your children or students, give them ample time to look at each work and form their own opinions; it certainly is not necessary to read the whole book in one sitting. Like a good book or movie, art can be enjoyed over and over again, each time with the possibility of revealing something that wasn't seen before.

You may notice that dates and other historical information are not included in the main text. I purposely omitted this information in order to focus on the art and those aspects of the world it illustrates. For children who want to learn more about the artists whose works appear in the book, short biographies are provided at the end, along with suggestions for further reading and a list of museums where you can see additional works by each artist.

After reading *How Artists See America,* children can do a wide variety of related activities to extend and reinforce all that they've learned. In addition to the simple activities I've suggested throughout the main text, they can research and visit historic sites in their home state, write a short skit based on one of the pictures in the book, or paint a picture of one of the country's famous landmarks. Since the examples shown here are just a tiny fraction of the great works of art that feature America as their subject, children can go on a scavenger hunt through museums, your local library, or the Internet to find other images of the United States.

I hope that you and your children or students will enjoy reading and rereading this book and, by looking at many styles of art, discover how artists share with us their unique ways of seeing and depicting our world.

ARTISTS' BIOGRAPHIES

(in order of appearance)

If you'd like to know more about the artists in this book, here's some information to get you started:

THOMAS COLE
(1801–1848), *pp. 4–5*

This artist, famous for painting American landscapes, was actually born in England. As a young man, he worked for a short while as an engraver before moving to Philadelphia, Pennsylvania. He took drawing classes at the prestigious Pennsylvania Academy, and shortly thereafter moved to New York City. In 1825 Cole took a trip to the Hudson Valley just north of New York City, where he saw the beautiful countryside that would become the main subject of his paintings for many years to come. As the leading member of the Hudson River School, a group of artists who made romantic landscape paintings of the Hudson Valley and other parts of the eastern United States, Cole's vivid imagination and attention to detail set his landscapes apart from the others in the group. In 1836 Cole left New York City and settled in the Hudson Valley, where he lived and worked for the rest of his life.

JOSEPH STELLA
(1877–1946), *pp. 6–7*

Born and raised in Italy, artist Joseph Stella moved to New York City at age nineteen. He quickly fell in love with the city that he liked to call his "wife," and with the immigrant communities of lower Manhattan. Early in his career, Stella worked as an illustrator and made many impressive drawings of the steel mills in and around Pittsburgh,

Pennsylvania. New York City gave Stella inspiration for many works of art, and in 1917 he began working on sketches and paintings of the Brooklyn Bridge, a subject that he would revisit until the end of his life. Although Stella worked in many different styles, his most characteristic style is futurism, which celebrates the energy and motion of machinery and technology. In addition to oil paint, Stella made works of art in many different media, such as watercolor, pastel, and charcoal. He is also known for collages made from pieces of paper he found on the street. To the end of his life Stella continued to search for new ways of seeing the world and expressing what he saw in his art.

CHILDE HASSAM
(1859–1935), *pp. 8–9*

This American painter's actual first name is Frederick, but he decided to take the name Childe after a favorite relative. During his teens, Hassam worked in a publishing company, an experience that led him to become an illustrator. At age nineteen he enrolled in a Boston art school and studied drawing and painting. He later traveled to Europe to study the French paintings of the day. After his return to America, Hassam began painting in the style of the French Impressionists, painters who used pure colors to capture the effects of light. His work was well received back home, and he began to show his "American Impressionism" with other American artists working in the same style. Later in his life, he returned to his roots as a printmaker, and made many etchings and lithographs until the end of his career.

WINSLOW HOMER
(1836–1910), *pp. 10–11*

The American artist Winslow Homer was born in New England but moved to New York City as a young man to become an illustrator. When the Civil War broke out, Homer was hired by a popular magazine to make pictures of the front. After the war he continued making illustrations but spent more and more time painting scenes from everyday American life in the realistic style he is famous for. After someone asked him to describe one of his canvases, the artist replied, "I regret very much that I have painted a picture that requires any description." In 1881 he traveled to England, where he lived in a seaside fishing village, an experience that took his art in new directions. When he returned to America he began to paint – in both watercolors and oils – rugged pictures of the sea. He liked to use watercolors to paint from nature, especially the seaside, and he used some of these watercolor studies as ideas for his oil paintings. Winslow Homer is one of America's most beloved artists because he was able to capture the spirit and beauty of a young nation in his art.

ALICE RAVENEL HUGER SMITH
(1876–1958), *pp. 12–13*

When this American artist was just a little girl growing up in South Carolina, her grandmother predicted that she would become an artist. Born into a wealthy family just eleven years after the end of the American Civil War, Alice Smith lived and worked in Charleston, South Carolina, for her entire life. Unlike other artists of the day who were studying art in France and New York, Smith chose to study art in her home town. Using the lush countryside as inspiration, Smith would spend hours outdoors, and then use her memory to create paintings and illustrations. Although she was skilled in painting with both oils and watercolors, she preferred watercolors because they better captured the "soft haze and quiet distances" of her beloved state. In addition to her work as an artist, Smith was a historian and was active in many Charleston art and civic organizations.

ROMARE BEARDEN
(1912–1988), *pp. 14–15*

The American artist Romare Bearden once said, "I think the artist has to be something like a whale, swimming with his mouth wide open, absorbing everything until he has what he really needs." Bearden absorbed what he saw around him, and combined his observations with his childhood memories to create art. He spent most of his childhood in Harlem, a predominantly African-American neighborhood in New York City. After college he attended art school and began to search for his own individual style. He loved music, especially jazz, and would listen to it as he worked, trying to express its rhythms in his art. In the 1960s Bearden began to make collages that show the hopes, dreams, and experiences of African Americans. His collages combine many different materials, such as photographs, paper, fabric, and paint. While Bearden also produced many oil paintings and drawings, he is best known for these beautiful works of mixed-media art, which celebrate the joys and sorrows of daily life.

THOMAS HART BENTON (1889–1975), *pp. 16–17*

This opinionated artist from Missouri was part of a small group of artists known as American Scene painters. In the 1930s many American painters were making abstract art, consisting of only line, shape, and color, not realistic, recognizable subjects. But Benton believed that American painting should portray the American landscape and its people. Whether painting a farm scene or a subway, Benton used rounded forms and curving lines to express the dynamic spirit of America as he saw it. The people in Benton's work are often strong, muscular, and graceful, like those in the work of one of his favorite artists, the Renaissance master Michelangelo. Benton was also a skilled writer and teacher of art.

NELL CHOATE JONES (1879–1981), *pp. 18–19*

Nell Choate Jones was born in Georgia just three years after Alice Smith, and like Smith, would live to celebrate in art the land and traditions of the South. Jones's father was a high-ranking officer in the confederate army. After his death the family moved to Brooklyn, a borough of New York City. For many years she worked as a classroom teacher, and at the age of forty was awarded a scholarship to attend art school in Europe. Once back in the United States, she devoted herself more fully to painting, exhibiting her work and receiving positive reviews. After a family trip to Georgia, the South became a common subject of her work. Jones was deeply involved with the Brooklyn art community, and continued to live and work there until her death at age 102.

GEORGE CALEB BINGHAM (1811–1879), *pp. 20–21*

George Caleb Bingham was born in Virginia, but would become known for his pictures of Midwestern frontier life. His family moved to Missouri when George was a boy, and after his father died he went to work to support his family. As a young man, Bingham studied art for a brief time at the Pennsylvania Academy in Philadelphia and found work as a portrait painter, but it was his "genre" paintings, scenes from everyday life, that people loved. To help his work be seen by many people, engravings were made from his paintings and widely circulated, bringing him fame and a following that would later help him build a career in politics. In 1848 this painter of the American Midwest served in the Missouri legislature, and was the state treasurer from 1862-1865.

GRANT WOOD (1892–1942), *pp. 22–23*

Born in Iowa, Grant Wood showed artistic promise as a child. After high school, the shy teenager set off for art school in Missouri, but shortly returned to Iowa to become a classroom teacher. The following year he decided to return to art school and enrolled in The Art Institute of Chicago. During World War I Wood served in the army as a camouflage painter, responsible for painting the khaki and green patterns on tanks and other military equipment. After his tour of duty Wood once again returned to Iowa and began teaching art. In the early 1930s Wood and other painters founded an art school in Iowa to encourage artists to create works that capture the spirit of the Midwest. Like Thomas Hart Benton,

this American Scene painter is best known for his pictures of farmers at work, rolling green fields, and portraits of people from the American heartland.

HARVEY T. DUNN (1884–1952), *pp. 24–25*

"I prefer painting pictures of early South Dakota life to any other kind . . . my search for other horizons has led me around to my first." So said South Dakota artist Harvey Dunn about the state that he loved. While he was attending a farming college, a teacher noticed his talent for drawing. Shortly afterward, Dunn enrolled in The Art Institute of Chicago and then began his career as an illustrator. Dunn took a break from his work illustrating books and magazines during World War I to become a captain in the American Expeditionary Forces. Stationed in France, he and other artists made pictures of battles and life on the front lines. Back on American soil, Dunn moved east and taught art in New York City. He nevertheless spent his summers in South Dakota, where he drew inspiration from the land and history of his native state.

FRANCIS BLACKBEAR BOSIN (1921–1980), *pp. 26–27*

The Native American artist Francis Blackbear Bosin descends from the Comanche and Kiowa tribes and was named after his grandfather, a Kiowa chief. As a boy he was inspired to become an artist by looking at the art work of other Kiowa in the school library. He began to study painting seriously while in the Marine Corps in Hawaii, and shortly after that began exhibiting his paintings. The Bosin paint-ing featured in this book, Prairie Fire, was featured in National Geographic magazine, which brought him national fame and is a good example of the artist's bold use of color and line. Deeply interested in the history and customs of the Kiowa people, Bosin continued to make pictures that depict his ancestors until his death.

FREDERIC REMINGTON (1861–1909), *pp. 28–29*

As a boy growing up in upstate New York, Frederic Remington spent hours drawing, an activity he preferred over school. While in college at Yale University, this American artist whose work would become the most well-known expression of the American West excelled more on the athletic field than in the classroom. After college, Remington headed west and held a variety of jobs, and even worked for a while as a cow-boy. It was at this time that Remington fell in love with Western frontier life and began to draw everything that he saw. He sold one of these drawings to a popular magazine, and thus began his career as a successful illustrator of stories, books, and articles. Remington is known for his action pictures of cowboys and Native Americans on horseback, as well as bronze sculptures of bucking broncos. Because his work captures this exciting time in American history, Remington is one of the country's most beloved artists.

GEORGIA O'KEEFFE (1887–1986), *pp. 30–31*

When the American painter Georgia O'Keeffe was twelve years old, she told a friend that she would become an artist. She went to art school and later became a teacher. When she was twenty-five

years old, she sent some of her watercolor paintings to her best friend, who showed them to a gallery owner in New York City. The gallery owner was Alfred Stieglitz, a photographer who would later become her husband. Stieglitz was so impressed with O'Keeffe's pictures that he hung them up in his gallery without even asking her permission! That was the start of her long and amazing career as an artist. Her paintings show ordinary things in unusual and unexpected ways, such as a single flower that fills up the whole canvas, sun-bleached animal skulls, seashells, and desert hillsides.

THOMAS MORAN
(1837–1926), *pp. 32–33*

Like another American landscape painter, Thomas Cole, Thomas Moran was born in England and moved to the United States as a boy. Growing up in a poor family in Philadelphia, Pennsylvania, Moran had no formal art training, and taught himself to paint. He once said, "You can't teach an artist much how to paint. I used to think it teachable, but I have come to feel that there is an ability to see nature, and unless it is within the man, it is useless to try and impart it." This painter of the grand, dramatic vistas certainly could "see nature," and on an expedition to the American West Moran was hired to paint pictures of the area now known as Yellowstone National Park. His paintings of Yellowstone, along with photographs taken by a partner, helped convince the United States Congress in 1871 to make this remarkable area a national park. Moran was the first artist to sell a painting to the United States government: a huge canvas called *The Grand Canyon of the Yellowstone,* which was hung in United States Capitol building. The painting now hangs in the Department of the Interior Museum in Washington, D.C.

DAVID HOCKNEY
(born 1937), *pp. 34–35*

From his earliest childhood, Hockney loved to draw. In math class, when he was supposed to be doing his lessons, he would draw instead. At age eleven, when this Englishman decided to become an artist, he believed that "anyone was an artist who in his job had to pick up a brush and paint something." At thirteen he sold his first painting, a portrait of his father. After grade school, Hockney went to the Royal College of Art, where he began to form his own personal style. He is known for his paintings of sparkling blue swimming pools, still lifes, and interiors, as well as portraits of friends and collages made from hundreds of photographs. This popular artist lives and works in California, another one of his favorite subjects.

SUGGESTIONS FOR FURTHER READING

FOR EARLY READERS (AGES 4–7)

Venezia, Mike. *Grant Wood.* Getting to Know the World's Greatest Artists series. Chicago: Children's Press, 1995. This easy-to-read biography includes color reproductions and humorous illustrations to capture the personality and talent of this American painter.

Winter, Jeanette. *My Name is Georgia.* New York: Silver Whistle (A division of Harcourt Brace and Company), 1998. In this charming book, the author tells the story of O'Keeffe's remarkable life, enhanced by her own words and with illustrations made in the artist's unique style.

FOR INTERMEDIATE READERS (AGES 8–10)

Brown, Kevin. *Romare Bearden.* Black Americans of Achievement series. New York: Chelsea House Publishing, 1995. This biography of the African-American artist provides a thorough overview of his life and work.

Hughes, Langston. *The Block: Poems.* Illustrated by Romare Bearden. Introduction by Bill Cosby. New York: Viking Children's Books, 1995. The title of this collection of poetry

by noted poet Langston Hughes borrows from Bearden's painting of the same name, which hangs in The Metropolitan Museum of Art in New York. Hughes's poetry, paired with sections of the painting, creates a dynamic combination of words and images.

FOR ADVANCED READERS (AGES 11+)

Beneduce, Ann Keay. *A Weekend with Winslow Homer.* New York: Rizzoli, 1993.
This informative and clever book takes the reader back in time to meet the American painter, who narrates the story of his life.

Duggleby, John. Artist in Overalls: *The Life of Grant Wood.* San Francisco: Chronicle Books, 1996.
For intermediate to advanced readers, this thoughtful biography traces the life of the American scene painter from his childhood in Iowa to adulthood.

Turner, Robyn Montana. *Georgia O'Keeffe.* Portraits of Women Artists for Children series. Boston: Little, Brown and Company, 1991.
The fascinating story of O'Keeffe's life is told and illustrated with many of her most well-known paintings.

WHERE TO SEE THE ARTISTS' WORK

ROMARE BEARDEN

- Albright-Knox Art Gallery, Buffalo, New York
- California African-American Museum, Los Angeles
- The Carnegie Museum of Art, Pittsburgh, Pennsylvania
- High Museum, Atlanta, Georgia
- Howard University Gallery of Art, Fisk University, Nashville, Tennessee
- Mint Museum of Art, Charlotte, North Carolina
- National Museum of American Art, Smithsonian Institution, Washington, D.C.
- North Carolina Museum of Art, Raleigh
- Sheldon Memorial Art Gallery, University of Nebraska, Lincoln
- The Studio Museum, New York, New York
- http://www.artcyclopedia.com/artists/bearden_romare.html

THOMAS HART BENTON

- Albrecht-Kemper Museum of Art, St. Joseph, Missouri
- Bakersfield Museum of Art, Bakersfield, California
- Barbara and Steven Grossman Gallery, School of the Museum of Fine Arts, Boston
- Hunter Museum of Art, Chattanooga, Tennessee
- The Metropolitan Museum of Art, New York, New York
- Minnesota Museum of Art, St. Paul
- National Gallery of Art, Washington, D.C.
- National Museum of American Art, Smithsonian Institution, Washington, D.C.
- The New School for Social Research, New York, New York
- Sheldon Swope Art Museum, Terre Haute, Indiana
- Whitney Museum of American Art, New York, New York
- http://monet.unk.edu/mona/contemp/benton/benton.html

GEORGE CALEB BINGHAM

- Butler Institute of American Art, Youngstown, Ohio
- The Detroit Institute of Arts, Detroit, Michigan
- Fine Arts Museum of San Francisco, San Francisco, California
- Hunter Museum of American Art, Chattanooga, Tennessee
- The Metropolitan Museum of Art, New York, New York
- Minneapolis Institute of Arts, Minneapolis, Minnesota
- National Portrait Gallery, Smithsonian Institution, Washington, D.C.
- Nelson-Atkins Museum of Art, Kansas City, Missouri
- Washington University Gallery of Art, Saint Louis, Missouri
- http://www.artcyclopedia.com/artists/bingham_george_caleb.html

FRANCIS BLACKBEAR BOSIN

- Bureau of Indian Affairs, United States Department of the Interior, Washington, D.C.

- Denver Art Museum, Denver, Colorado
- Eiteljorg Museum of American Indian and Western Art, Indianapolis, Indiana
- Thomas Gilcrease Institute of American History and Art, Tulsa, Oklahoma
- Heard Museum, Phoenix, Arizona
- Old Cowtown Museum, Wichita, Kansas
- The Philbrook Museum of Art, Tulsa, Oklahoma

THOMAS COLE

- Albany Institute of History and Art, Albany, New York
- The Art Institute of Chicago, Chicago, Illinois
- Butler Institute of American Art, Youngstown, Ohio
- Maier Museum of Art, Randolph-Macon Women's College, Lynchburg, Virginia
- The Metropolitan Museum of Art, New York, New York
- Munson-Williams Proctor Institute, Utica, New York
- Museum of Fine Arts, Boston, Massachusetts
- Museum of Fine Arts, Houston, Texas
- National Gallery of Art, Washington, D.C.
- National Museum of American Art, Smithsonian Institution, Washington, D.C.
- The New-York Historical Society, New York, New York
- Sheldon Memorial Art Gallery, University of Nebraska, Lincoln
- Terra Museum of American Art, Chicago, Illinois
- Utah Museum of Fine Arts, University of Utah, Salt Lake City
- http://sunsite.dk/cgfa/c/c-11.htm#cole
- http://www.thomascole.org/

HARVEY DUNN

- National Museum of American Art, Smithsonian Institution, Washington, D.C.
- South Dakota Art Museum, Billings, South Dakota

CHILDE HASSAM

- The Art Institute of Chicago, Chicago, Illinois
- Butler Institute of American Art, Youngstown, Ohio
- Frye Art Museum, Seattle, Washington
- Hyde Collection Art Museum, Glens Falls, New York
- Los Angeles County Museum of Art, Los Angeles, California
- The Metropolitan Museum of Art, New York, New York
- Minneapolis Institute of Arts, Minneapolis, Minnesota
- Mint Museum of Art, Charlotte, North Carolina
- Museum of Fine Arts, Boston, Massachusetts
- National Gallery of Art, Washington, D.C.
- Norton Museum of Art, West Palm Beach, Florida
- Worcester Art Museum, Worcester, Massachusetts
- http://www.sunsite.dk/cgfa/hassam/hassam3.htm

DAVID HOCKNEY

- The Art Institute of Chicago, Chicago, Illinois
- The Contemporary Museum, Honolulu, Hawaii
- John Paul Getty Museum, Los Angeles, California
- Los Angeles County Museum of Art, Los Angeles, California
- The Metropolitan Museum of Art, New York, New York

- Museum of Contemporary Art, Los Angeles, California
- Museum of Fine Arts, Boston, Massachusetts
- National Gallery of Art, Washington, D.C.
- New Orleans Museum of Art, New Orleans, Louisiana
- Philadelphia Museum of Art, Philadelphia, Pennsylvania
- Tate Gallery, London, England
- http://www.mcs.csuhayward.edu/~malek/Hockney.html

WINSLOW HOMER

- Addison Gallery of American Art, Phillips Academy, Andover, Massachusetts
- The Art Institute of Chicago, Chicago, Illinois
- Butler Institute of American Art, Youngstown, Ohio
- The Currier Gallery of Art, Manchester, New Hampshire
- Delaware Art Museum, Wilmington
- Freer Gallery of Art, Smithsonian Institution, Washington, D.C.
- Los Angeles County Museum of Art, Los Angeles, California
- Museum of Fine Arts, Springfield, Massachusetts
- National Gallery of Art, Washington, D.C.
- National Museum of American Art, Smithsonian Institution, Washington, D.C.
- North Carolina Museum of Art, Raleigh
- Philadelphia Museum of Art, Philadelphia, Pennsylvania
- Portland Museum of Art, Portland, Maine
- San Diego Museum of Art, San Diego, California
- Wichita Art Museum, Wichita, Kansas
- http://www.boston.com/mfa/homer/mfahomer.htm

NELL CHOATE JONES

- Morris Museum of Art, Augusta, Georgia
- High Museum of Art, Atlanta, Georgia

THOMAS MORAN

- Autry Museum of Western Heritage, Los Angeles, California
- Brigham Young University Museum of Art, Provo, Utah
- Brooklyn Museum, Brooklyn, New York
- Buffalo Bill Historical Center, Cody, Wyoming
- The Cleveland Museum of Art, Cleveland, Ohio
- Cooper-Hewitt Museum, National Museum of Design, Smithsonian Institution, New York
- Department of the Interior Museum, Washington, D.C.
- The Detroit Institute of Arts, Detroit, Michigan
- Museum of Fine Arts, Boston, Massachusetts
- National Museum of American Art, Smithsonian Institution, Washington, D.C.
- New Britain Museum of American Art, New Britain, Connecticut
- North Carolina Museum of Art, Raleigh
- San Diego Museum of Art, San Diego, California
- Stark Museum of Art, Orange, Texas
- http://www.nga.gov/feature/moran/

GEORGIA O'KEEFFE

- Albuquerque Museum of Art, History, and Science, Albuquerque, New Mexico
- The Art Institute of Chicago, Chicago, Illinois
- Birmingham Museum of Art, Birmingham, Alabama

- Brooklyn Museum of Art, Brooklyn, New York
- The Metropolitan Museum of Art, New York, New York
- National Museum of Women in the Arts, Washington, D.C.
- New Jersey State Museum, Trenton, New Jersey
- Philadelphia Museum of Art, Philadelphia, Pennsylvania
- The Phillips Collection, Washington, D.C.
- Phoenix Art Museum, Phoenix, Arizona
- Reynolda House Museum of American Art, Winston-Salem, North Carolina
- Carl Van Vechten Gallery of Fine Arts, Fisk University, Nashville, Tennessee
- Virginia Museum of Fine Arts, Richmond
- Whitney Museum of American Art, New York
- http://www.okeeffemuseum.org/indexflash.html/
- http://sunsite.dk/cgfa/okeeffe/index.html

FREDERIC REMINGTON

- Amon Carter Museum, Fort Worth, Texas
- Bakersfield Museum of Art, Bakersfield, California
- Berman Museum of World History, Anniston, Alabama
- Buffalo Bill Historical Center, Cody, Wyoming
- Eiteljorg Museum of American Indian and Western Art, Indianapolis, Indiana
- Thomas Gilcrease Institute of American History and Art, Tulsa, Oklahoma
- vHeard Museum, Phoenix, Arizona
- Joslyn Art Museum, Omaha, Nebraska
- National Cowboy and Western Heritage Museum, Oklahoma City, Oklahoma

- Palm Springs Desert Museum, Palm Springs, California
- Frederic Remington Art Museum, Ogdensburg, New York
- Sid Richardson Collection of Western Art, Forth Worth, Texas
- The Rockwell Museum, Corning, New York
- http://fredericremington.org./

ALICE RAVENEL HUGER SMITH

- The Gibbes Museum of Art, Charleston, South Carolina

JOSEPH STELLA

- Ackland Art Museum, University of North Carolina, Chapel Hill, North Carolina
- Hirshhorn Museum and Sculpture Garden, Smithsonian Institution, Washington, D.C.
- Montclair Art Museum, Montclair, New Jersey
- Museum of Fine Arts, Boston, Massachusetts
- National Museum of American Art, Smithsonian Institution, Washington, D.C.
- Newark Museum, Newark, New Jersey
- Phoenix Art Museum, Phoenix, Arizona
- Portland Art Museum, Portland, Oregon
- Reynolda House Museum of Art, Winston-Salem, North Carolina
- Sheldon Memorial Art Gallery and Sculpture Garden, University of Nebraska, Lincoln
- Whitney Museum of American Art, New York, New York
- http://artcyclopedia.com/artists/stella_joseph.html

GRANT WOOD

- Amon Carter Museum, Fort Worth, Texas
- The Art Institute of Chicago, Chicago, Illinois
- Cedar Rapids Museum of Art, Cedar Rapids, Iowa
- Kalamazoo Institute of Arts, Kalamazoo, Michigan
- Lakeview Museum of Arts and Sciences, Peoria, Illinois
- The Metropolitan Museum of Art, New York, New York
- Minnesota Museum of Art, St. Paul
- National Museum of American Art, Smithsonian Institution, Washington, D.C.
- Reynolda House Museum of Art, Winston-Salem, North Carolina
- Sheldon Swope Art Museum, Terre Haute, Indiana
- Sioux City Art Center, Sioux City, Iowa
- Strong Museum, Rochester, New York
- Whitney Museum of American Art, New York, New York
- http://www.artcyclopedia.com/artists/wood_grant.html

CREDITS
(listed in order of appearance)

Thomas Cole (1801–1848). *Distant View of Niagara Falls,* 1830. Oil on panel, 18⅞ x 23⅞ in. (47.9 x 60.6 cm). Friends of American Art Collection, Photo: The Art Institute of Chicago. Joseph Stella (1877–1946). *The Brooklyn Bridge: Variation on an Old Theme,* 1939. Oil on canvas, 70 x 42 in. (177.8 x 109.7 cm). Whitney Museum of American Art, New York. Childe Hassam (1859–1935). *Allies Day, May 1917,* 1917. Oil on canvas, 36½ x 30¼ in. (92.7 x 76.8 cm). National Gallery of Art, Washington. Gift of Ethelyn McKinney in memory of her brother, Glenn Ford McKinney. Winslow Homer (1836–1910). *Breezing Up (A Fair Wind),* 1873–76. Oil on canvas, 24³⁄₁₆ x 38³⁄₁₆ in. (61.5 x 97 cm). Gift of the W.L. and May T. Mellon Foundation, National Gallery of Art, Washington, D.C. Alice Ravenel Huger Smith (1876–1958). *Bayou Scene,* c. 1920. Watercolor on Whitman board, 21½ x 16¾ in. (54.6 x 42.5 cm). The Morris Museum of Art, Augusta Georgia. Romare Bearden (1912–1988). *New Orleans Ragging Home,* 1974. From the Of the Blues series. Collage with acrylic and lacquer on board, 36½ x 48 in. (92.7 x 121.9 cm). © Romare Bearden Foundation Inc. Licensed by VAGA, New York, NY. Thomas Hart Benton (1889–1975). *Cotton Pickers,* 1928–29. Egg tempera with oil glaze on canvas, 30 x 35¼ in. (76.2 x 89.5 cm). The Metropolitan Museum of Art, George A. Hearn Fund, 1933. Photograph 1980 The Metropolitan Museum of Art, New York. Nell Choate Jones (1879–1981), *Georgia Red Clay,* 1946. Oil on canvas, 25 x 30 in. (63.5 x 76.2 cm). The Morris Museum of Art, Augusta, Georgia.

George Caleb Bingham (1811–1879). *Fur Traders Descending the Missouri,* c. 1845. Oil on canvas, 29 x 36½ in. (73.7 x 92.7 cm). The Metropolitan Museum of Art, Morris K. Jesup Fund, 1933. Photograph 1992 The Metropolitan Museum of Art, New York. Grant Wood (1891–1942). *American Gothic,* 1930. Oil on beaverboard, 29¼ x 24⅝ in (74.3 x 62.4 cm). Friends of American Art Collection, all rights reserved by The Art Institute of Chicago and VAGA, New York. Harvey T. Dunn (1884–1952). *The Prairie Is My Garden,* 1950. Oil on canvas, 36 x 60 in. (91.4 x 152.4 cm). The South Dakota Art Museum, Brookings. Francis Blackbear Bosin (1921–1980). *Prairie Fire,* c. 1953. Gouache on brown paper, 20¼ x 33⅛ in. (51.4 x 84.1 cm). The Philbrook Museum of Art, Tulsa, Oklahoma. Frederic Remington (1861–1909). *A Dash for the Timber,* 1889. Oil on canvas, 48¼ x 84⅛ in. (122.6 x 213.7 cm). Amon Carter Museum, Fort Worth, Texas. Georgia O'Keeffe (1887–1986). *Summer Days,* 1936. Oil on canvas, 36 x 30 in. (91.4 x 76.2 cm). Whitney Museum of American Art, New York; Gift of Calvin Klein. Thomas Moran (1837–1926). *Cliffs of the Upper Colorado River, Wyoming Territory,* 1882. Oil on canvas, 16 x 24 in. (40.6 x 60.9 cm). National Museum of American Art, Smithsonian Institution, Washington, D.C., Bequest of Henry Ward Ranger through the National Academy of Design. David Hockney (born 1937). *Mulholland Drive: The Road to the Studio,* 1980. Acrylic on canvas, 86 x 243 in. (218.4 x 617.2 cm). Los Angeles County Museum of Art, Los Angeles.